DISGUISE
TECHNIQUES

DISGUISE
TECHNIQUES

Edmond A. MacInaugh

CITADEL PRESS SECAUCUS, NEW JERSEY

Published 1988 by Citadel Press
A division of Lyle Stuart Inc.
120 Enterprise Ave., Secaucus, N.J. 07094
In Canada: Musson Book Company
A division of General Publishing Co. Limited
Don Mills, Ontario

Manufactured in the United States of America
ISBN 0-8065-1098-6

Previously published by Paladin Press.

CONTENTS

DISGUISE
TECHNIQUES

INTRODUCTION

While disguise in our society is mainly limited to entertainment purposes or reserved for Halloween, its history is long and varied. The art of disguise has long been practiced by such disparate types as actors, travelers, Ninja warriors, criminals and refugees of all kinds, spies, members of the Committee to Reelect President Nixon, CIA agents, fugitives from paternity suits and child-care payments, border crossers, and many others.

As we will see in these pages, there is more to disguise than putting on a costume. As in the martial arts, the art of disguise, properly practiced, requires mental conditioning, self-knowledge, and the ability to size up others and predict their movements.

If you are serious about learning to disguise yourself, study and practice the exercises in this book, consider the observations and theories presented herein, and then go on to develop your own individual skills, costume techniques, alternate personalities, and theories. With persistence, I guarantee that you will be able to fool anyone—even your own mother!

Which of the following people waiting for the bus are in disguise? The clown disguise is the most obvious. The child may believe the clown's looks are real, being too young to know that things are not always as they appear. Other observers immediately see that he is disguising himself, but

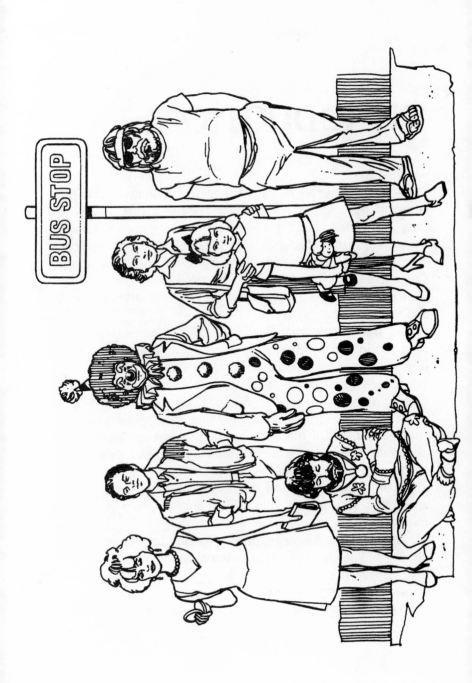

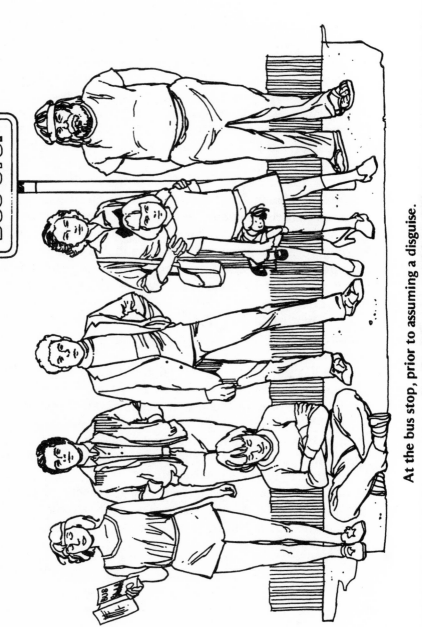

At the bus stop, prior to assuming a disguise.

unless they are familiar with him and his clown suit, they won't be able to recognize him in his street clothes.

The woman on the left is wearing a subtle but effective kind of disguise. While she has not obscured her features, she has changed her normal appearance by dolling up. The man standing next to her is attracted to her, or rather to her disguise, but when he sees her jogging past his house without that disguise, she will be just part of the landscape to him. Ordinarily, he would be striking up a conversation with her as he waits for the 202 Downtown, but right now he can't; it would spoil his disguise.

He is attempting to pull off a neutral or chameleonlike disguise by blending into his surroundings in such a way as to render himself "invisible" and pass unnoticed.

The young woman assuming a half lotus on the sidewalk is using yoga relaxation, an exercise suitable to the personality of her disguise character, in order to calm herself down. She is afraid her facial hair adhesive will come unstuck and she'll be discovered.

The mother and child are pretty much as they always appear, although the child would rather be wearing a Wonder Woman costume.

The fat guy in the headband could be in disguise. His mother, if she saw him now, would certainly think he was, but he hasn't been in touch with her for three years. He has changed his identity because of a computer embezzlement scam in his past and has changed his name, papers, personal appearance, place of residence, and lifestyle in order to ensure the safety of his new identity.

As you can see, disguise is a theme with many variations, and the would-be disguise artist has much to learn about himself and others before he even begins to put together his costume.

1. PSYCHOLOGY OF INVISIBILITY

There are countless disguise possibilities to suit every situation, from the obvious—like the old fake-nose-and-glasses gag—to the extremely subtle. Physical disguise is usually a cover-up designed to make the wearer unrecognizable. A clown suit, a false beard, and a stocking over the head are all physical disguises. They don't camouflage the wearer; they can, in fact, make him stand out in a crowd. But they do make him difficult to identify.

The art of psychological disguise, on the other hand, lies in making oneself "invisible" in a particular situation. The disguise artist develops the chameleonlike ability to blend into his surroundings so well that he cannot be seen as a separate entity. Just as a chameleon is perceived as being part of a pattern of leaves and twigs, so the disguise artist is perceived as being part of the pattern of a busy city street. The best disguise, as we shall see, does not always require a costume.

THE DISGUISE OF NOT-BEING

Not-being is a state of mind. It could be described as the antithesis of "be here now." You have probably practiced not-being when you were in a bad mood, trying to avoid someone at the hardware store, or at other times when you didn't want to be noticed.

If this doesn't sound familiar, think back to what you

used to do in school when you didn't want the teacher to call on you. Probably, you cleared your mind of activity as much as possible, you held still and kept quiet so as not to attract attention, and you avoided looking at the teacher. Right? Now remember the *feeling* of trying not to be called on. This is basically the state of *not-being*.

But, you may say, the teacher used to call on me on purpose when I did that! If so, he or she was experienced enough in classroom conduct to recognize and search out students who had not completed their homework. In everyday situations outside of school, however, people are too caught up in their own affairs to notice anyone or anything that does not demand their attention. Remember: People respond to stimulus, not to a lack of stimulus.

To achieve the state of not-being, you must clear your mind, remaining calm and confident. You must not arouse suspicion by acting furtive or attract attention by making noise, taking up too much space, or moving quickly (unless everyone else is moving quickly). And you must *not* establish eye contact.

In Ninja training, students are taught to avoid not only eye contact, but also staring at opponents, even when behind them. This training stems from the belief that people intuitively sense scrutiny and will instinctively turn to see who is staring at them.

Few people aside from martial artists have any conscious knowledge of the state of not-being, but its practice is nonetheless widespread. Timid folk slide into this neutral zone whenever they are in a public place, simply because they feel embarrassed when they are paid too much attention.

Not-being works by itself or in combination with a camouflage disguise. Self-conscious teenagers, for example, may adopt what their elders assume to be outlandish costumes and hairstyles, simply to conform with the rest of their crowd.

I know one woman who purposely practiced not-being every time she boarded the San Francisco trolley that took her to and from work. An old raincoat of indeterminate age and color helped put her in the right frame of mind. She made herself small, averted her eyes, and imagined she was somewhere else. The conductor always passed her by—she was never once asked for her fare!

If you work at attaining and maintaining this state of mind, you will discover that you can go about your daily work, shopping, and so on, as if you were invisible. Few people will notice you or pay you any mind. As you learn to quiet your mind at will, you will discover how others react to your "vibrations," or mental state. You will learn to monitor your output so that your presence cannot be felt.

Not-being as a disguise technique is applicable only to certain situations. There are many occasions, which we will discuss in a later chapter, when it definitely will not work. It is a useful tool, however, for any disguise artist to learn.

STEREOTYPES

It is human nature to see strangers as stereotypes rather than as individuals. As we shall see, the disguise artist can become adept at using this tendency to his own advantage. Stereotyping is the result of mental laziness—or of mental efficiency, depending on how you look at it. It is easier to class people by category than to attempt to judge everyone you see by his individual characteristics. Friends, family members, and others who we know well rate separate headings in our mental filing systems, but strangers, if remembered at all, are usually jammed in under general headings and broad labels. When a person is perceived as a stereotype, his individual features are likely to be either forgotten or remembered incorrectly. All Orientals really do look alike to

many Caucasians, for examp!e, just as many Orientals think all Caucasians look alike.

For this reason, fitting other people's preconceptions can be an excellent disguise. Those readily classified as types are invisible—within the proper context, of course. Usually the best stereotypes to adopt for disguise purposes are non-threatening. Nonthreatening people as a rule arouse little emotion and are thus apt to be overlooked.

Some examples of invisible people are:

- servants
- waiters, waitresses
- housewives
- gas station attendants
- construction workers
- businessmen
- students
- mailmen and UPS men.

The list can be extended indefinitely. Seen in the right place at the right time, a person fitting one of the above types will scarcely merit a first glance, let alone a second. In some locales, a businessman sporting a polyester suit and toting a briefcase would stick out like a sore thumb, while a cowboy would be invisible. A UPS man wandering around a residential neighborhood without a truck for any length of time would eventually call attention to himself. Obviously, some discretion is required.

The point is, people see what they expect to see. A cleaning lady at a bus stop, a waiter in a restaurant or country club, or a mechanic at a filling station won't be accorded more than a cursory glance.

CONTEXT

Context is an essential ingredient of invisibility; it works hand in hand with stereotypes. If your disguise fits a common stereotype that is substantially different from the image

you normally project, you are not likely to be recognized later in your "real-life" role.

This principle operates all the time in everyday situations. When we see someone in a context different from the one in which we have classified him, we find him difficult to place. Let's say, for example, that you see Sheila, a waitress at Harry's Bar and Grill, three or four times a week. You always give her your order and engage in some small talk and banter. Naturally, at Harry's you recognize Sheila immediately.

Then one day you run into her at the rifle range, or at the supermarket, wheeling three kids in a shopping cart, or at the opera, and you look right through her. You simply do not see Sheila at all.

This is an example of unconscious stereotyping. You have categorized Sheila as *waitress;* in your mind, she belongs at Harry's. When you see her in another context, such as shootist, mother, or opera buff, you are unable to recognize her. Some small characteristic gesture on her part at this point could identify her. On the other hand, you might never make the association at all.

We have mentioned so-called invisible people. Highly visible people—those who fit common stereotypes with a powerful hold on the imagination—are also useful to impersonate. Disguised as one of these types, you can imprint an image so powerfully on the minds of observers that they will not recognize you out of context.

Highly visible people often represent sexuality or authority to others. How many TV ads can you remember that do *not* use either sexy models or alleged experts in order to get their point across? Danger, good fortune (especially wealth and fame), and bad fortune (disease, injury, extreme poverty) also tend to make people highly visible. As with all stereotyping, the highly visible person is perceived not as an individual but as a representative of some group or as a symbol of some idea. An actress or rock star may be seen as the per-

sonification of sexuality; while a mother might be seen as a personification of virtue.

Acting in an overtly authoritative or sexual manner will usually make a strong impression on others, and this impression will be remembered long after your baby blue eyes and lumpy nose are forgotten. Discard your role and you throw away your disguise. If you perform well, you will be unrecognizable out of context.

Examples of highly visible stereotypes are:

- prostitutes
- racial types other than one's own
- hippies (outdated, but still part of many people's stereotyping system)
- nuns
- priests
- rock musicians
- pregnant women; mothers
- police officers
- vagrants or winos.

The vagrant disguise is especially useful because, while the vagrant is threatening to many and therefore makes his presence keenly felt, no one wants to look at him closely for fear of drawing his attention. The poor derelict obviously needs something, and what most people don't need is someone who needs something. There are only a few Good Samaritans among us desirous of attracting a penniless, diseased, possibly dangerous, drug-crazed, drunk, and malodorous panhandler.

These stereotypes will work to disguise you only if they are totally uncharacteristic of the lifestyle you normally lead or the person you normally appear to be. In other words, if you strike people generally as a dangerous, penniless, drug-crazed, drunk, malodorous kind of guy, then the vagrant disguise is not for you. Impersonate a nun instead.

One story, this one true, illustrates the importance of stereotyping and context in disguise situations. Back in the

sixties, two women I knew were aiding and abetting John Sinclair, then a fugitive from the law. The FBI, knowing something was up, had the women's house staked out. Whenever they left, they were followed and were unable to shake the agents that were tailing them. Finally the two women hit on a plan that worked perfectly. They would leave the house in their usual hippie attire, bell-bottoms, bare feet, long, straight hair, and so on, carrying brown paper bags. The agents would trail them to an office building. There, the women went into a rest room with their paper bags and some time later reappeared as secretaries, complete with high heels, nylons, dresses, purses, makeup, bouffant hairdos, the works. Chatting casually as they clicked down the sidewalk in their high heels, they would glance across the street to see the patient agents still watching the office building and waiting for the hippie chicks to resurface. The women used this same ploy on several different occasions, and it worked every time.

All of which just goes to show that you can be invisible in your psychological disguise because observers will see their own mental images, not you. All you do when you personify a stereotype is trigger a series of images and associations that were formed in the mind of the beholder long before you ever appeared on the scene.

The true story of Jim Peabody and Brownie the Cop is a good example of the way people see only what they expect to see.

Brownie's real name was Ed Brown. He and Jim were the ringleaders and principal rebels of the wild crowd in my high school. After graduation most of the kids in that crowd went their separate ways and settled down to become reasonably respectable members of society. Brownie joined the local police force, and Jim stole a couple of cars, sold one for parts, and expeditiously left town in the other. From time to time, we heard reports of Jim, none of which were the

type to make his mother especially happy. It seems he had taken to writing bad checks and was involved in a number of bunco scams down South, although the law never quite managed to catch up with him.

One Christmas, Jim came home to visit his mother. She had started taking in boarders after Jim left, but she always kept his room ready for him. Word got out, as it will in a small town, and Brownie determined to make himself a hero by nabbing his old high school buddy. Since this was his own idea and not a police assignment, Brownie showed up after having gone off duty on Christmas Eve. Parking his new Mustang outside the boarding house, he approached with gun drawn and let himself in without knocking.

Only Mrs. Peabody was in the living room, and she assured him that she had not heard from Jim. She told Brownie to put his gun away and have some eggnog, but he insisted on searching the bedrooms. As he went up the stairs, an old man with a cane passed him going down.

"Merry Christmas, sonny," the old geezer croaked, but Brownie was too intent on his duty to answer or pay him any mind. Until, that is, he heard his Mustang revving up.

Brownie got to Jim's bedroom window in time to fire a couple of shots at Jim as he sped away—to Florida, as we later heard. It was not surprising that Brownie's shots all missed, because, as everybody knew, Brownie was much too fond of his new car to risk shooting it full of holes. Unfortunately for Brownie, he never saw that Mustang or his old friend Jim again, and if the law ever caught up with Jim, I never heard.

Brownie believed that the old man he had passed on the stairs might be able to provide a clue to Jim's whereabouts, but he never returned to the boarding house. The strangest part, Brownie said, was that the other boarders denied that there had ever been an old man living there at all.

2. DISGUISE PREPARATION

For a Halloween party or a parade, simply climbing into a costume will do just fine. If you are serious about disguising yourself in situations where keeping your identity secret is imperative, however, you will need to prepare more carefully before beginning. The most important thing you can learn to do is to sharpen your senses, particularly your powers of observation.

LEARNING TO SEE OTHERS

The Game of the Stones

In order to teach their students to skillfully observe and retain detailed information about the enemy, Ninja martial arts instructors have devised the game of the stones. The teacher, or *sensei*, places several objects in a box and then allows the student to examine them as thoroughly as he wishes. After this, the sensei closes the box and asks the student to describe the contents in detail, including the number of each type of object.

When the student has become adept at this level, the sensei helps him examine a more complicated collection of objects, purposely miscounting the number of one type of object. If the student, in recounting what he has observed after the box is closed, repeats his instructor's error, the sensei corrects him. The lesson to be learned is that the student

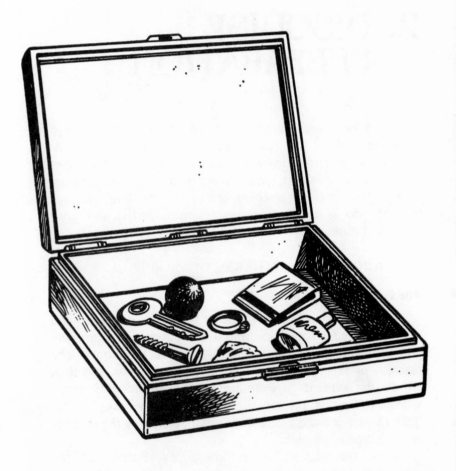

Game of the Stones

must believe his own experience and never accept the information of others in place of his own perceptions. If the student gives a correct count, the sensei congratulates him and explains the trick and the reason for it.

The student may then be requested to describe the box itself. This will probably be difficult because he has been concentrating on the contents, not the container. The lesson to be learned from this is to not become so caught up in detail that you miss the big picture; don't miss the forest for the trees (Ashida Kim, *Ninja Secrets of Invisibility.* Boulder, Colorado: Paladin Press, 1983).

The game of the stones has relevance for the disguise artist who, like the Ninja, must learn to scrutinize others while avoiding scrutiny himself. The disguise artist must also develop his powers of perception and memory, learn to trust his own experience, and be aware of the overall situation as well as the details that make up the whole. These skills are necessary not only to know the enemy, but also to blend in with, imitate, and deal anonymously with various individuals or groups whom the disguise artist may or may not regard as "the enemy."

Your Own Stereotypes

We have discussed stereotypical thinking, i.e., categorizing people by type. Now it is time to discover how *you* stereotype or categorize others. In all likelihood, you engage in stereotypical thinking to some extent, whether or not you are aware of it. There is nothing intrinsically wrong with categorizing people by type—in fact, it is necessary at times—but the disguise artist needs to be aware of how and why he does so in order to see others without the distortion of his own biases getting in the way. No one can become a master of disguise without first learning to see others clearly.

The importance of seeing others clearly for purposes of impersonation is illustrated in the following extract from

Crimson Web of Terror (Paladin Press, Boulder, Colorado).

> Three top leaders of the Cuban 26 of July Movement, Armando Hart, Antonio Buch, and Javier Pazos, left the Sierra Maestro Mountains in January of 1958, after meeting with Fidel Castro. Disguised as farmers, they went to the city of Bayamo where they boarded a train for Santiago de Cuba. Within several minutes they were arrested by a suspicious policeman. The tell-tale sign that tipped off the officer was their muddy shoes. No Cuban campesino would board a train or go to the city with muddy shoes.

Dressing and acting according to your *preconceptions* of a certain group (i.e., farmers have muddy shoes) can be risky.

One method of developing one's powers of observation is to collect a group of photographs of people, singly or in crowds, from magazines. Select three or four of these pictures and examine them carefully. Now lay them aside and jot down your impressions of the subjects of each photograph. Comment on such matters as glasses, facial hair, dress, imagined personality or character type, and what the subject is doing. You may be surprised at how difficult this exercise can be at first.

Compare your descriptions with the subjects as you look back over the photographs. Are there discrepancies between your observations and what you see? If so, try to figure out why. What caught your eye and gave you a false impression? If you remembered a subject with reasonable accuracy, what about the subject's appearance made him or her memorable to you? You will probably start to become aware of your prejudices, preconceptions, and stereotypes. Awareness is what you want.

Another exercise helpful in developing awareness of

stereotypical thinking requires nothing more than a newspaper. It need not even be current. Simply leaf through the paper, looking at the pictures and ignoring the headlines and captions. Try to guess who the people depicted are and what they do for a living. See whether you can tell the good guys from the bad guys. Then check to see how you did.

Your score really doesn't matter as much as what you find out about how you assess people. You may realize that you were mentally slandering a great guy because he reminds you of a former employer whom you never liked. Or maybe you misjudged a convicted child porn photographer because he looks just like sweet old Uncle Earl. You will probably find that sometimes you're right on target in your perceptions of others, too. It is important to take stock of your strong points as well as your weaknesses.

Whether or not you are an accomplished photographer, you can profit from shooting a roll of film or two. All you need for this exercise are a loaded camera and pencil and paper for taking notes. A small spiral notebook or the back of an envelope is fine. Go to a public place where there are plenty of people—a tourist attraction is best—and act like a vacationer. Shoot buildings, scenic vistas, or whatever. Don't give the impression that you're photographing people, even though this is exactly what you are doing.

Number your pictures and scribble a hasty note with some description to help you remember each shot as soon as possible after you've taken it. It won't do to look at the subjects of your photograph as you write. As a rule, people do not like to be watched or to have their actions recorded by strangers, even if all they're doing is hanging around the state capitol building. Use this exercise as an opportunity to practice your chameleonlike powers of invisibility; think of yourself as a harmless shutterbug taking in the sights. Shoot only a few frames at first, or you will find it impossible to remember your subject matter.

Back at home, use your notes to prod your memory. Allow yourself plenty of time to ruminate and recollect as you add to your description of each shot. (What are the people doing? What do they look like?)

Now finish off your roll of film taking snaps of the family dog or your old Harley or whatever else appeals to you, and then drop it off to be developed. If you have your own dark room, so much the better. And if you have a Polaroid, great—just try not to cheat. After you get your snapshots back, look at them carefully, comparing what you see with your notes (which you have, of course, carefully preserved).

As you improve at this exercise, you will be able to observe your subjects more closely without seeming to notice them at all. You will also learn to absorb information quickly and easily and retain it for longer periods of time. The discipline of using a camera will get you into the habit of seeing in a methodical way. You will become more aware of detail— not only in human physical appearance, but in landscape, weather, light and shadow, and so on. And, with practice, you will develop the habit of seeing people in an impersonal, almost clinical manner instead of through the distorting lens of preconception and visual stereotyping.

As you increase your awareness, pay attention to style of hair, clothing, and footwear. Observe the kinds of automobiles, bicycles, and pets people choose. As you learn to notice individual differences and preferences, you will simultaneously become cognizant of more types than you had ever dreamed existed. This is all to the good. Make a point of eavesdropping, really listening to the ways different types of people talk, what they talk about, and what they do while they're talking.

The new generalizations you form, based on accurate observation, will be invaluable to you as a disguise artist. With practice, you will be able to impersonate people from

many different backgrounds and of many types with relative ease. After some time, it will become second nature.

To help develop your impersonation skills, watch TV and movies with a critical eye. If a character strikes you as courageous, kind, cowardly, or cruel, figure out what it is about the actor or actress that impresses you in this way. Get into the habit of recognizing physical and behavioral cues that lead you to make assumptions about character. You will find that facial expressions, gestures, posture, dress, speech, and other factors all contribute to forming your opinion. Sure, the people on the screen are only actors—but acting is a big part of successful disguise, as we will see in the following chapter.

LEARNING TO SEE YOURSELF

Now we come to the hard part! After all, you're used to watching other people, but probably the only time you see yourself is when you look in the mirror. Even then, chances are you don't see yourself as others see you, for a variety of reasons. Most of us see only what we want to see in ourselves or, conversely, zero in on a gray hair or minor blemish that no one else would notice. It is almost impossible to get a good idea of our facial expressions, posture, or gestures from our stints before the looking glass. Seeing yourself honestly may be painful at first, but it is necessary if you are serious about disguise.

A good place to start is with a list of your physical characteristics. Some can be changed temporarily, some can be compensated for with illusion techniques, and some are definite disguise handicaps. Coloring and facial hair can be changed, for example. Attention can be drawn away from a large nose or receding hairline. But if you are four-foot-eight or six-foot-ten or weigh in at 500 pounds, you will have to work hard to disguise yourself.

List all the physical characteristics you can think of:

coloring, hair or lack of it, teeth, facial shape, height, weight, scars, tattoos, and so on. As a general rule, the more average you are, the easier physical disguise will be for you. Don't despair if you're not average, though—just think of your distinctive characteristics as a challenge.

Audio: A tape recorder is an asset in self-observation. If you have never listened to your own voice on tape, you will probably be surprised at the way you sound. Read, ad-lib, talk to friends and family. Forget about the recorder if you can; this will give you a better idea of your true speech patterns. Self-consciousness will inhibit you so that you speak only in a limited way, analogous to posing before the mirror. It is most revealing if you laugh, yell, mispronounce words, slur your sibilants, or whatever else you do when you are speaking normally.

Listen to the tapes you make of yourself, and listen to other people. Compare the way you sound with the way they sound. As an exercise, tape yourself imitating another person or speaking in a regional accent different from your own. Unless you are a talented mimic, your first attempts will probably be easily recognizable. Tone, pitch, pronunciation, pauses, and a host of other personal peculiarities are apt to give you away. Remember that practice makes perfect and keep at it.

Video: Video is technology's gift to the disguise artist. A portable video camera can be bought, rented, or otherwise obtained, and you can watch yourself on TV—in color, if your set will oblige.

Don't just stand there: move around, talk, sing, perform a few routine chores on camera. If you are a smoker, smoke. Longest established habits like smoking tend to express a personal style. They are very revealing, while at the same time almost entirely unconscious. Tape yourself with friends and family. Once again, loosen up and try to forget you are taping yourself. Then play it back on your set and watch carefully.

How do you come across? What sort of person do you appear to be on TV? What do you do that gives this impression? How do you stand? How do you walk? Do you point your toes out like a duck, or in like a pigeon? Do you stride along or mince like a geisha? Do you swing your arms or your hips?

People are usually pleasantly surprised when they see themselves on video tape. (Hey, that's my kinda guy!) Sometimes there are unpleasant surprises in store, too. One man I know participated in a public speaking class during his stint in the U.S. Coast Guard. In order to show the salts how they appeared to others when they spoke, each speech was recorded on video tape, then played back for instructive purposes. When this man watched himself bending his head over his notes on TV, he was shocked to see a bald patch on the top of his head toward the back. This was the first he had been aware of it.

Figure out what you could change in your behavior that would make you seem like a different sort of person, and experiment with it in front of the camera. Try pretending you are someone else. Study the results on your set and try again.

This is a difficult but fascinating exercise—after all, who is more interesting than you?—and one that yields excellent results.

How Do You Come Across?

Use this self-evaluation quiz in conjunction with the video self-examination.

	In General	Sometimes	Not at All

I consider myself to be:

Hard working
Nice
A leader
Charming

	In General	Sometimes	Not at All
Short-tempered			
A good sport			
Successful			
Patient			
Energetic			
Religious			
Cheerful			
Hard to fool			
Softhearted			
Shy			
Reserved			
Attractive			
Responsible			
Creative			
Wild			
Stable			
A risk-taker			
Well-groomed			
Hostile			
Gullible			
A perfectionist			
Domineering			
Resourceful			
Spontaneous			
Courageous			
Tough			
Self-controlled			
Independent			
Affectionate			
Easy-going			
Loyal			
Calm			
Careful			

	In General	Sometimes	Not at All
Active			
Aggressive			
Law-abiding			
Timid			
Rebellious			
Family-oriented			
Sincere			
Assertive			
Insecure			
Practical			
Passive			
Sexy			
Lazy			
Eager to please			
Humorous			
Unemotional			
A loner			

(Other traits you might think of)

Watch and listen to yourself on tape. Compare your answers with the person you see and hear on the screen. Does your projected image agree with your self-assessment? In other words, if you were to meet your screen personality, would he or she fit your self-description?

It is very likely that your video image will correspond closely with the personality profile you have outlined for yourself in taking the quiz. Without being aware of it most of the time, we all adapt our behavior, facial expressions, posture, and mannerisms to fit the image we have of ourselves. Other people tend to accept us as being the way we present ourselves. This doesn't mean that we have no alternatives to the way we normally project ourselves!

It is also likely that you found several contradictions

while taking the quiz. You may be hard to con on some occasions, for example, and gullible on others; you may be timid in some situations and courageous in others. Think about these differences, trying to feel the way you would under various circumstances, and then act them out on video tape.

While you are taping yourself, try to change one or two of the aspects of the personality you usually project. (If you think you come across as careful and reserved, imitate a carefree and spontaneous person. Remembering occasions on which you have *felt* carefree and spontaneous will help you.)

3. WHO WAS THAT MASKED MAN?

A physical disguise can be as simple or as complicated as you want to make it. In some cases, the "bag over the head" or cover-up disguise will suit your purposes better than any other. When your aim is simply to render yourself unrecognizable for a short time, and especially when a quick getaway is in order, an elaborate costume is more trouble than it's worth, and may even be incriminating. In situations· like these, your disguise should be:

- able to cover up your individual, or characteristic, features
- generic and commonly available
- easy to put on and take off
- easy to dispose of.

We tend to think of our "individual features" as our facial features, hair, and facial hair. Portraits, snapshots, and mug shots emphasize the face. We speak of a familiar face in the crowd; when we picture a friend or loved one, we generally see a face in our mind's eye rather than some other part of the anatomy. Covering the head and face is therefore of paramount importance in the physical disguise—but don't overlook other distinguishing features!

You draw attention to yourself when you obscure your face. People instinctively become uneasy when confronted with a heavily masked stranger. Not only do they suspect that the masked person is up to no good, they also feel

uncomfortable simply because the natural habit of scanning the facial features is thwarted by such a disguise. Because of this, people will notice the rest of the body and clothing more than they would otherwise.

Fear reactions to head and face cover are instinctive. Small children are often reduced to panic at the sight of a parent in a Halloween mask, even when the mask is donned in a playful spirit in front of the little one. Many children, in fact, are afraid of their own masked reflections in the mirror. Once I saw adults become irrationally angry at a costume party when one guest refused to remove his Ninja warrior disguise, thus keeping his identity secret for the entire evening. Even dogs can be intimidated or made vicious by the sight of a human friend in a threatening mask although their sense of smell tells them who the intruder is. Our airedale, Otis, became quite violent when a friend appeared one night in Darth Vader headgear. After the disguise was removed, the dog continued to bark at it and try to bite it, and he has not really ever trusted the man who wore it since. Otis has never seen "Star Wars," so one must assume that it was the disguise principle, not Darth's evil personality, that threw him off the scent.

Because we can't see the facial expressions that give us cues to emotion, we are unable to predict the behavior of the masked man or woman, and this inability to predict makes us feel insecure, more especially because we assume—often with good reason—that the masked person is disguised for nefarious purposes. Fear sharpens scrutiny and, because we cannot study the face, we concentrate on the rest of the body, body language, dress, voice, or anything else that will give us a clue as to what sort of person we are dealing with and what he is up to.

All of this leads to the point that if you are covering your head you should not assume, like the ostrich with its

head in the sand, that no one can see you. You are actually highly visible, and your clothing, voice, speech patterns, walk, tattoos, and any other distinguishing characteristic will probably be noted.

The physical disguise should be common enough that you cannot be traced by means of your costume. This is what is meant by a *generic* disguise. Despite what the advertisements say, one nylon stocking looks much like another, especially when worn over the head. A ski mask would be difficult to trace in Aspen, Colorado, but might be incriminating in Houston, Texas, especially if it were found in your possession after the fact. Whether you choose to wear a bed sheet or a paper bag, make sure that your costume is something that won't be readily traced back to you and won't give you away if it is later discovered in your car, briefcase, or apartment. Silver bullets worked all right for the Lone Ranger, and Clark Kent managed to keep his rather distinctive outfit well concealed, but all in all, you will doubtless find it more practical to use less highly individualized disguises and accessories.

Because the cover-up disguise is most useful in situations where you will be doing a quick in-out, you will want to choose one that can be quickly and easily put on and removed. When not in use your disguise should be inconspicuous and easily portable. When you are wearing it, it should stay on reliably so that you won't have to worry about whether or not your false nose will fall off at the crucial moment.

Ideally, this kind of disguise is cheap and simple enough that you won't mind throwing it away when you are through with it. The same Peruvian ski mask, for example, worn on several different occasions, might serve to link those occasions in the minds of the police and media ("the Peruvian ski mask incidents") and thus ultimately provide a clue to

your identity. Even a totally nondescript, generic disguise worn on successive occasions might eventually provide such a link.

The other obvious reason for disposing of your disguise is to avoid having it discovered on your person or among your effects by someone capable of putting two and two together. It should be discarded far enough away from the scene *and* from your car or hang-out that it won't be recognized and associated with the disguise event. The concept of psychological invisibility works here; if the article is common enough, it won't arouse suspicion when left in a litter bin or dumpster. An old nylon stocking, for example, discarded in a spot where cast-off clothing and other debris is an everyday sight, will not be noticed. A nylon left in a trash basket in a public men's room might arouse curiosity. Out of context, even a common article is visible. Make sure your fingerprints, hair, and so on are not on the disguise, no matter where you choose to dispose of it, just to be on the safe side.

In summary, the cover-up type of physical disguise is useful when your objective is to be unrecognizable for a short period of time, after which you will remove yourself from the scene, preferably with alacrity, and then remove and dispose of the disguise article. It is important that the disguise article not be traced to you, and therefore it should be discarded in a place where it is not out of context, a safe distance from your residence or place of business and also from the place in which you wore it. Just in case it is discovered by some sleuth, it should not have your fingerprints, hair, or blood on it. Then, if it is a common item, no link to you can be proven, or even rationally suspected.

Two more points about the cover-up disguise are in order. First, although it will generally render the wearer highly visible, there are exceptions to this rule. When a heavy disguise is in the context of the occasion, it can make the wearer invisible as well as unrecognizable. Examples of this are Mardi

Gras and Halloween celebrations, where elaborate disguises are commonplace. In such situations, the quick in-out and getaway may not be the disguise artist's objective; he may instead want to mingle, observe, or pull off some subtle maneuver that will not be discovered till later, after the revelers have gone their separate ways. When the disguise is elaborate, it is especially important that it be disposed of in a way that cannot lead to identification of the disguise artist. If a giant iguana was seen rifling the desk of the costume party host, it might be difficult to explain the presence of an iguana suit in your closet the next day.

The second point is that the fear reaction to a cover-up disguise may at times be used to the disguise artist's advantage. Medieval Japanese samurai armor often included headgear with terrifying iron masks, complete with exaggerated scowls, teeth, and long mustaches. Even when viewed in the calm of a museum, samurai armor is somewhat unsettling. Worn on the battlefield by sword-wielding, screaming horsemen, it threw opposing troops into confusion and disarray. The same principle operates with the simpler cover-ups. Observers typically feel frightened and confused when they perceive themselves threatened by a masked stranger, and this reaction can buy the disguise artist some time in which to conclude his operation and get out of the vicinity.

THE CHAMELEON

The beauty of the chameleon disguise is that it doesn't look like a disguise. Done properly, it doesn't look like anything at all. The whole point is to blend unobtrusively with your surroundings so that you are, for all practical purposes, invisible. The chameleon disguise is suitable for quiet mingling, surreptitious scrutinizing, and any situation in which you want to be present but unnoticed. It is fine for infiltrating meetings and generally hanging out, watching, and listening. Chapter 1 deals with this subject in more detail.

QUICK-CHANGE DISGUISE

Quick change is useful when you want to be one person going into a place and another person coming out. Usually some sort of costume is required.

For an education in quick-change techniques, visit a department store in a big city and observe how the shoplifters and store detectives operate. A detective might duck into a back room to switch hats, trade a briefcase for a knapsack or a sportcoat for a sweatshirt so as not to be recognized or suspected by his quarry. If you were to observe a group of detectives on a daily basis as I did, you would come to recognize them easily no matter what they were wearing. The regular shoplifters—the ones everybody knew were stealing, but whom nobody could catch in the act—were also hip to the store detectives and appeared to enjoy the game of cat and mouse they were playing. Very few of the detectives I observed were expert in the art of disguise; no matter what costume they put on, they obviously still felt and behaved like store detectives. Because anyone familiar with the situation could see them coming a mile away they were usually able to catch only rank amateurs. Very seldom did a store detective exhibit the mental training and acting skill necessary to foil an experienced thief. Those who were most successful would appear as different types each time, a bank clerk one minute and a pimp the next.

The game was played by both sides, of course. The regulars had many different ploys, techniques, and styles, but not many bothered with disguise—unless they were so good I never noticed. Sometimes a shoplifter, realizing that he was being tailed, would duck into a restroom and emerge disguised, giving the detectives the slip. Few of the thieves showed any more skill or creativity than did the detectives, but those that were good were astounding.

Many people mistakenly believe that simply changing clothes, adding a mustache, putting in a pair of colored

contacts, or blacking out a tooth constitutes a quick-change disguise. Nothing could be further from the truth. In actual practice, these small changes may not be noticed at all! Remember that any disguise you choose must effect a radical departure from your previous image. You must give the initial impression of being in a different category, and let context work for you. You need not go to such ridiculous lengths as Peter Sellers did in his Inspector Clouseau movies, but that is the general idea—just don't make yourself quite so conspicuous!

Much of the quick change depends on you, your needs in a specific situation, and how much extra gear you can carry without attracting attention. If there is a chance that your disguise materials might be found on your person with incriminating results, then this must be taken into account, too. As with many other aspects of disguise, carrying things inconspicuously is easier for women than for men. Large purses, shopping bags, and even diaper bags are considered normal gear for women to lug, but not so normal for men. Men with a lot of disguise articles to carry may consider a briefcase, tackle box, golf club bag, or camera bag. You will have to use your ingenuity to find a method that is practical and within the context of your disguise.

The last chapter deals with makeup technique and other methods of physical disguise. The disguise artist, however, cannot afford to depend completely upon such props. Keep in mind what you have learned from your self-examination exercises, and try to play down any really noticeable characteristics you may have, like posture, walk, gestures, voice, and accent. Higher-heeled shoes such as cowboy boots will make you walk differently than low heels; shower thongs may have a similar effect, although to a lesser degree. Experiment to see how you can change your hairstyle and clothing to create a totally different impression.

Personality change can be a help with quick-change dis-

guise, too. If you usually come across as Mr. Personality or Ms. Self-Assertion, try alternating with a chameleonlike, "invisible" personality combined with a compatible physical disguise. Don't act furtive or sneaky, just low-key. Or try it the other way around, if you have enough nerve: go in like a lamb and go out like a lion. The hardest part of this may be acting sufficiently subtle so that you don't attract too much attention. Amateurs tend to oscillate between thinking that some small change—small, that is, to the rest of the world, but momentous to them—will render them unrecognizable and alternately feeling that an outrageously conspicuous outfit is called for. Striking a balance is important, but easier said than done. It is simply not easy to see ourselves as others see us. Again, video work helps. Having a trusted friend or family member to try out your disguises may even be helpful, if you think he or she will be honest in assessing the success of your disguise and when secrecy is not essential. In some situations, it is neither fair nor practical to assume that anyone will keep such information quiet.

VEHICULAR DISGUISE

All your skill in making yourself unrecognizable will go for nothing if your vehicle can be recognized or traced. The following tips will give you some ideas on concealing your vehicle, and you should be able to improvise your own from there. The psychology of invisibility can apply to automobiles, bicycles, and what have you. *Generic* is the key word here. Your vehicle should be so plain and unassuming, within its context, that no one will be likely to see it.

Certain cars are invisible almost anywhere. I'm referring to mid-size, mid-seventies GM models with light-colored paint jobs. This was a nebulous era for American-made automobiles. Even a Detroiter with an interest in the automotive industry would be hard-pressed to make a positive identification on

one of these. Light colors, especially white, blue, and green shades, tend to be less noticeable than others. A 1967 light green Nova or Grenada is another example of an invisible car.

These days bumper stickers are a popular means of self-expression. If your rear windshield and bumper are plastered with stickers, you may be so accustomed to seeing them that you don't notice them anymore—but other people will. Remove them. You don't need everyone to know you think "Soccer Is a Kick in the Balls," or that you're a Scorpio, or to beep if they love Jesus, especially when you're traveling incognito.

Bumper stickers, hula dancers in the rear windshield, and pompoms dangling from the rearview mirror can, however, be used to disguise your car, if you have time to duck into a hiding place and remove them unseen. Such ornaments are useful to round out a disguise personality or to reinforce a stereotype that you are impersonating. A typical tourist might be expected to have opened road maps littering the seats, a Polaroid or Instamatic in the back, and a "See Lookout Mountain" sticker on the bumper. All of these could be speedily and unobtrusively removed and deposited in the trunk on short notice. Make sure that any stickers you use for disguise purposes are modified with rubber cement or some other nonpermanent adhesive for easy removal.

For occasions when tire tracks might tend to incriminate you, have a set of old tires that you can afford to throw away after the fact. Replace them with your regular tires afterward—your common sense will dictate time and place—and dispose of the old tires in a spot that will not attract attention.

Side panels can be changed, just as you change your costumes. Old cars frequently have panels with mismatched paint jobs, and you can mix or match as the situation warrants.

If you want to disguise the color of your vehicle, as well as the impression it creates, spray it with a fine mist of oil, then drive along a dusty road until it is sufficiently dirty to obscure its true shade. To remove the disguise, run it through the car wash..

To temporarily change the color of your car, spray it with a waterbased paint—*not* acrylic. (Acrylics will wash off with soap and water when wet, but will rapidly dry and adhere to the existing paint on your vehicle. Commercial automobile paint is acrylic-based.) Poster paint will do the trick. To remove the disguise, drive to the car wash. This disguise is unsuitable for rainy climates, in case you haven't already figured that out. A slight drizzle will have you worrying; a cloudburst will blow your cover and make you look ridiculous in the bargain.

DISGUISING THE OFFICE OR LIVING AREA

There may be times when you will want to disguise the room in which you hold a meeting. When you can use a building that isn't yours, all the better. Even your own office or living room can be adequately disguised for some purposes, however. Your room or office is an extension of yourself and a reflection of you. By manipulating your surroundings, you can add a new dimension to your disguise personality.

It is best to start out with an empty room and then add from there. Otherwise, if the space is your own turf, you may neglect to remove everyday articles that will reveal something of your real-life identity to your guest. Such mundane objects as a dog dish, a bottle of fingernail polish, or an NRA magazine will make an impression. Keep furnishings as simple and commonplace as possible within the context of the situation. Think of it as setting a stage, adding objects and adjusting lighting to enhance the impression you want to give of the situation and your disguise character.

Although your guest will probably not be consciously aware of much of the decor, you must be cognizant of every detail. One or two pieces calculated to attract attention may be a good idea. These could be anything from an eye-catching poster to a disemboweled motorcycle or an exotic plant. Remember, however, that you will soon be lugging out these articles and disposing of them so plan accordingly.

Potted flowers, a statue, even a pink flamingo by the entrance may be useful. You might tell your guest, "Look for the house with the bird bath and the flamingos on the lawn," and then cart them away after the fact.

After the disguise occasion, again remove everything from the room. You might repaint the walls a different color if you can do so without arousing suspicion. Then refurnish the room to create a completely different impression. If some of the same furniture is used, rearrange it. Curtains, rugs, and other decor can all be used to advantage in creating the effect you want to achieve. The lighting should be changed, too. The idea is to confuse and disorient the guest who returns to the scene or to discredit the observer who describes the disguised room.

The illusions you create will appeal real to the observer. You will be influencing him through the power of suggestion, so pay close attention to detail. By your choice of decor—or lack of it—you will be sending a message about who you are; be sure that you are in control of the message your guest receives.

4. FEEL LIKE A NEW MAN

There may be times when you will want to disguise your-self for an extended period of time or on repeated occasions in order to mislead a certain person or group of people as to your real identity. This is often necessary for purposes of infiltration and for personal reasons. The longer-term disguise differs from the one-shot cover-up in that it requires invent-ing and sustaining an individual personality rather than merely obscuring your true identity. It differs from the chameleon in that it demands presence and projection of personality, even if not your true personality, rather than practicing the discipline of not-being. Depending on your needs, you may want to develop a disguise personality that is consistently repeatable, allowing, however, for some small human inconsistencies to make your character believably three dimensional.

Longer-term disguise demands imagination, acting ability, skill in physical disguise technique, good powers of observa-tion, and more than a little nerve. Practice makes perfect, however, and the disguise artist finds the longer-term disguise the most enjoyable kind.

Keep in mind here what we have already discussed about stereotypical thinking and context. If, by your appearance, mannerisms, speech, facial expressions, and other signs, you convince your audience that you are a certain kind of per-son—especially a type for which they have a ready-made

mental label—they are apt not to recognize you later in your real-life role. Any police officer or trial lawyer can tell you that for every twenty witnesses of a crime or accident, there will be twenty accounts of what happened. The basic story will probably be much the same, but the visual details and interpretations will vary widely. This is not because the witnesses are dishonest or stupid, but because everyone sees things differently, according to his own preconceptions and biases. Your audiences may not be able to accurately recall your eye color or height, but they will be apt to remember their impression of your "type."

BECOMING THE ENEMY

Miyamoto Musashi, a samurai born in 1584 and a famous military strategist, wrote of learning to become the enemy. Thinking oneself into the position of the enemy, according to Musashi, enables the warrior to remain self-confident and win the battle.

"In single combat also you must put yourself into the enemy's position. If you think, 'Here is a master of the Way, who knows the principles of strategy,' then you will surely lose. You must consider this deeply."

The discipline of mentally becoming the enemy is valuable for the disguise artist; thinking only of yourself and how you are performing is of no use whatever. Remember that others will see you as the person you present yourself to be. Don't feel self-conscious about your costume. They won't know that you don't usually sport a mustache or that your plaid pants or wing tips are out of character unless you tell them. Don't tip the scales in their favor by assuming they can see through you. Video self-examination will help you get outside yourself enough to see your disguise from the other guy's point of view. This requires openness on your part more than the ability to psych out or analyze your audience.

If you can learn to think yourself into the other guy's position, self-confidence will be relatively easy to come by.

LEARNING TO ACT

Film actors and actresses often live their characters. An actor taking the role of a blind man, for example, might go about his daily tasks blindfolded or in complete darkness for weeks on end to develop a feeling for his character and the way his character approaches life. In any situation, imagine freely what your character would do. This is a creative, not an intellectual, exercise. It works best when you act intuitively rather than according to a script or set of rules. For examples of this kind of acting, study the films of Peter Sellers and Sir Lawrence Olivier. Different as they are in many respects, both will be remembered for their genius in creating a wide range of characters and making them all come to life.

If you are having trouble inventing a new personality for yourself, it is perfectly acceptable to borrow one from someone else, just to get started. Your boss or your Uncle Dave will do fine to begin with, as will anyone else you know well. You might prefer to imagine yourself in the boots of John Wayne in order to familiarize yourself with the technique. (It's best, however, not to use an impersonation of a famous person as your actual disguise. An obvious John Wayne or Richard Nixon impersonation is likely to be counterproductive!) You will be surprised to see how easy it is to visualize the way in which someone you know well would react to any given situation, even down to what he would say and how his face would look. This exercise is particularly useful because it develops awareness of alternative ways of acting and reacting, and after a certain amount of practice, it breaks down inhibitions against acting out of character.

Ego is a Latin word meaning "I am." In psychological

terms, the ego refers to the conscious self that controls behavior to suit real-life situations. In popular parlance, when we say that something hurts someone's ego, we mean that it wounds his self-esteem, shakes his sense of who he is. It is important to all of us to be able to say, "I am this; I wouldn't do that; I would always say such and such in this situation." We want to know who we are and to believe that we are essentially stable and unchangeable, despite some occasional ambivalence. Acting out of character, even in harmless, insignificant ways, can give your ego a jolt and disturb your sense of identity, especially if you have a rather strict sense of who you are. For some, the knowledge that they would always act in a specific manner on a specific occasion (like a *real* man, like a responsible citizen, like a good Christian) is the only thing separating a good self-image from a full-fledged identity crisis. It might help to remember that the characters you invent come from inside yourself. They are yours in the same way that any work of art you create is yours. Acting the disguise character is not a loss of identity but, on the contrary, a unique form of self-expression.

Despite a normal reluctance to act out of character, or in a way that doesn't conform to your self-image, it can be literally child's play after you have loosened up a little. Eventually you may even find that what you enjoy most is mimicking and predicting responses of a personality type very different from your own—or, at least, very different from the one you normally allow yourself to express. Most of our behavior is learned and reinforced by family, friends, and society, all of whom have a stake in our acting predictably. Inventing a character who refuses to act according to the rules of your normal role can be liberating, even cathartic. You will probably find yourself expressing opinions and emotions you never knew you had, revealing a whole new side of yourself in the process. You may not entirely approve of your invented character, but the chances are good you will become

very fond of him, if only because he acts out the things you "wouldn't do."

To get started on developing an out-of-character character, try acting with an attitude opposite to that which you would normally take. If you are an aggressive person, try acting passive in a few stressful situations. If you smile all the time (this is something you probably won't be aware of unless you videotape yourself interacting with others or make a conscious effort to be aware of it when you are with other people), work very hard not to smile for a whole day. This exercise will be difficult at first, and it will probably make you feel nervous, but that will be nothing to the exhileration you will feel when you slip the bonds of compulsive habitual behavior.

Perhaps you are already a social quick-change artist. With one group you drink and swear and play poker; with another you are urbane, sip Perrier, and dabble in "Trivial Pursuit." Your heartfelt views on immigration, marriage, and the Pope may vacillate somewhat depending on who you're with. The funny thing is that all of these responses, in keeping with different sets of expectations, are sincere. Ambivalence is common. Very few of us are absolutely consistent all the time.

Hard as we try to maintain a consistent image for ourselves and for the world, we are in fact full of contradictions. The person who is extreme in one characteristic will thus often dream of himself with an opposite characteristic in an unconscious attempt to achieve a balance. A man who politely suppresses his anger all day, for example, convincing himself he isn't angry at all ("I'm not the kind of guy who lets little things get to him") is apt to dream he is punching his antagonist in the nose. Both the passive and the violent reaction are equally his own and equally valid, although he may admit to only one. We are all familiar with the stereotypes of the prostitute with the heart of gold, the moral reformer who

neglects his family, and the outlaw who would never harm a child or a stray pup. Like most stereotypes, these are not to be taken literally, but they do have a grain of truth in them. People are too complicated to be all bad, all good, completely honest, absolutely crooked, and so on, even if it is easier to categorize them by thinking in terms of extremes.

None of this is meant to imply that you need to learn to act out all of the contradictory emotions on the "dark side" of your personality. You probably repressed many impulses with good reason if you are a reasonably normal member of society. It is healthy to learn to recognize all of your reactions, however, and to understand why you behave in a certain way. In all probability, there are a vast number of ways in which you can act and react in your disguise roles without seriously compromising your ethical standards or your true nature. Play-acting to tap your hidden depths can be useful, fun, and instructive; it need not be destructive. Many people feel that by letting go and acting uncharacteristically, they will somehow lose control, but in reality the opposite is true. By learning the full scope of your potential and building the power necessary to act in new ways in familiar situations, you will also develop greater powers of self-control.

The video self-examination discussed in Chapter 2 is a godsend in learning to act, enabling you to see yourself as others see you and to see your invented characters as others will see them. As you change certain aspects of your appearance and behavior, observe how your projected image is changing. A small tape recorder is also useful. I knew a man who successfully changed his west Texas accent to an Eastern prep school accent by imitating his roommate's voice on tape, playing it back, and trying again—countless times. It required considerable time and effort, but the transformation was perfect, down to the vowel sounds and figures of speech. Over a period of several years, I heard him revert to

his more colorful Texan speech patterns twice, once when he was caught in a traffic jam, and once at a party after having consumed a bottle of Rhinegarten wine.

A word of warning about character invention: Don't try pretending you're someone else around your spouse, family, or friends unless you're prepared to cause a stir. Their reactions can be expected to range from a vague feeling of insecurity ("something's wrong") to anger and hurt feelings. Sometimes those near and dear to a person who is not acting like himself feel so threatened that they ignore his behavior completely because it is not "real." Just as our egos keep us in check, telling us who we are and how to act in a given situation, we tend to keep our loved ones in check. We don't want them to be unpredictable. In an effort to keep everyone predictable and functioning according to expectation, even so-called antisocial behavior is often reinforced: "Oh, that's just the way Joe Bob is. He's always been that way!" The family may even insist by their attitudes and behavior that one member hold on to his bad habits, while they complain that nothing they can do will change him. This is why it is so hard to turn over a new leaf without first leaving home, and why it is so easy to revert to childhood patterns when you go back to visit the folks. In any event, trying out your personality changes around family and old friends is likely to be discouraging, especially in the early learning stages. Save your inventions for strangers—unless you really *want* to shake up the home front!

SHOPPING FOR YOUR COSTUME

Your first impression depends to a great extent on how you look to others. Rightly or wrongly, people will put you into a category right away on the basis of your physical appearance.

Have you ever grown or shaved a mustache or put on a new pair of glasses and then waited in vain for everyone to

notice? What seems to you a radical change may make no impression on others. People who see you every day may ignore a new haircut, a new shirt, or even a subtle change in hair color. Despite these alterations, you still present pretty much the same picture to the world. To disguise yourself effectively you must select costumes that convey a totally different image, not just a variation on your usual theme.

I once had a classical mythology professor who was a classic himself. He had been teaching the same course for generations. His note cards were yellow with age, and his voice, as he read them, was a distant drone. His tweed suit looked as if it were growing moss, although this was perhaps an illusion. We students naturally assumed that we had the old guy pegged—until the day he showed up looking like some ancient hippie in maroon bell-bottoms, love beads, and a huge "gay power" button. He acted exactly as usual, reading from his notes with the same monotonous voice and deadpan expression, yet an obvious transformation had occurred. This was an eight o'clock class, and I was pretty sure that I was still asleep and dreaming. I doubt that I would ever have recognized him out of context. My perception of reality was thrown off kilter for some time afterward.

Now, I will freely admit that maroon bell-bottoms, love beads, and an outsized "gay power" button are superficial accoutrements, but they are, I think, generally associated with a very different sort of person than one who wears mossy tweeds and drones on about Agamemnon and Clytemnestra. The venerable prof could have combed his hair up over his bald spot, changed his glass frames, and concealed his liver spots with Covermark without stirring a ripple in the classroom tedium. As it was, his seeming contradiction of his true nature (in reality, probably the one time he ever expressed anything of his true nature to us students, albeit in the form of a practical joke) kept us on our toes for the rest

of the semester. Class attendance improved as we waited for him to cross the line a second time. (He never did.)

All of which just goes to show that even if appearances don't make the man, they certainly make up our first impressions of the man. And, once again, our preconceptions and stereotypes play a big part in the way we see and think about a person.

This is why shopping for your costume—acquiring the physical part of your disguise—is so important. Refer back to the exercises on learning to see yourself and learning to see others before getting outfitted. Details can make or break your disguise.

If you know your disguise character backward and forward, inside and out, great—you'll know intuitively how he or she dresses for any occasion. If, however, you are trying to impersonate a person from a background with which you are not intimately familiar, develop that familiarity before attempting to fool others who may know more on the subject than you do. Undercover agents and police officers sometimes try to mingle with the masses, apparently unaware that their black shoes and hairstyles give them away. Anyone with an interest in recognizing them can see them coming a mile away. The undercover men who are adept at disguise may go about their work for years and never be found out.

To get a feel for your costume, go to garage sales or estate sales in the kind of neighborhood where your character would live. Browse around and get a feel for the kind of clothes that are being sold, and also for the clothes the buyers are wearing. Pay attention to the small stuff. Socks, for example, are important indicators of lifestyle. Forget about generics, and zero in on what makes this character's wardrobe unique. Authenticity is the watchword. If the character you will portray comes from a lower economic group than you do, simply wearing your old, worn-out clothes is not going to make it. If you think that your old golf shirt

and the madras bermudas that have been gathering dust in the closet for years will make you look like a penniless immigrant ("they wear shabby old clothes"), then you are reacting according to your own preconceptions, both of what penniless immigrants look like and what constitutes "old clothes." You won't be fooling anyone but yourself. Every group has its styles, whether or not they are visible to the casual observer. After you have trained yourself to look for these styles, you will be surprised how easy they are to identify and adopt. Some degree of interest and appreciation must be developed for these alternate dress codes as well. Contempt for your character's style, no matter how far it may stray from your personal taste, can undermine your ability to successfully costume yourself.

KNOW YOUR GROUP

Don't try to pass yourself off as a member of the specific social, racial, or geographic group with which you are intermingling unless you're the real thing. If you lack experience and background with this group, playing the part convincingly will be extremely difficult, if not impossible. Dialect, accent, manners, dress, personal references to supposedly shared experiences, education, place names, and a thousand little things that may never occur to you will all be waiting to trip you up. A true member of the group doesn't have to think about these things; they are second nature to him. He will, however, notice immediately when you make a mistake. Blowing the smallest detail can destroy the whole illusion that you have been carefully constructing, just as a pinprick bursts a balloon.

Examples of this are a man who has never been in the service with a group of Vietnam vets; a person who has never done drugs with a network of coke or heroin users and dealers; a woman from Kalamazoo in a club full of Londoners.

I'm sure you can think of many more examples. The possibiities of wrong matches are limitless.

And *never* be so crass as to try to break into a group by disguising yourself according to your stereotype of that group. This may seem so ludicrous that it makes you laugh, but people attempt it all the time. If you want to disguise yourself as a Dutch boy in wooden shoes, don't try it at the national tulip festival in Holland, Michigan. Don't attempt to infiltrate a Muslim meeting in blackface, or a Daughters of the American Revolution meeting in a dress cut from the American flag. Don't throw around expressions like "Hey, let's all toke down," and "This stuff is gonna blow your mind," when talking with a drug pusher. These are all exaggerations, of course. Any small slip on your part, however, is likely to seem as out of place to the group you are infiltrating as the examples above sound to you. A fake accent, done according to your stereotype of how Southerners sound ("Y'all come back now, heah?") may fool someone from Vermont, but no Georgia peach will go for it.

Don't imitate the group you want to infiltrate. Instead, try to be as different as possible. Then, even if you slip up, no one will be likely to notice or care. You can even use some stereotyping in your impersonation in this case, as long as it is a stereotype held by the people in the group you are infiltrating. Go light on this, but be aware of the advantages as well. You may have to feel it out. Your audience will like you better and distrust you less if they can laugh at you a little. Let them feel superior. They will usually reciprocate by considering you harmless and cutting you a lot of slack. People tend to enjoy stereotyping others, and if you give them the chance to stereotype you they'll love you for it. Talkative Irishmen, thrifty Scots (Star Trek's Scotty is a good example of the beloved Scot stereotype), rich Texans, dumb blondes . . . you get the picture. If you are not too heavy-handed in your impersonation, you can suggest to your

audience that you are a typical member of whatever group you choose, and they will gladly do the rest. Playing on other people's stereotypes is simple, like painting by numbers. Just give them a few clues and they will know exactly how the rest of the picture is supposed to be filled in. But get ready to be patronized. "Oh yes, he's a (fill in the blank), but he's a good one; he's not like the rest of them!"

The same principles lend themselves to many variations and disguise uses. You may not be interested in infiltrating a group or in being liked, but you can still use the theories discussed above to suit your own needs. A man I knew often used other people's stereotypes to his advantage, adapting disguise techniques to his everyday life. He was a well-educated and well-spoken fellow, but not ambitious. At this particular point, he was driving a school bus and felt irritated by demands of parents and teachers that he alter his bus route to suit their convenience. The people making the demands were all professionals, and the driver knew the common white-collar stereotype of blue-collar workers. When someone requested that he make any alteration in his routine, he would simply growl, "I ain't artherized." The person making the request would then immediately back off—for good. What's the use, he figured, in trying to reason with a rude (and possibly even violent—you know how the lower classes are) bus driver? Nobody bothered to report him, either. After all, he was only doing the job he had been "artherized" to perform, and, according to the stereotype, no more could be expected. The same psychology applies to many disguise situations, whether you are trying to crack a car theft network or merely get out of driving a couple of extra blocks.

When you plan to use the same disguise with the same person or people on more than one occasion, make sure that you are reasonably consistent. Certainly, no one looks or acts exactly the same every day. You won't want to wear

exactly the same outfit unless you have a special reason for doing so, and you are entitled to some minor variations in mood. On the other hand, you don't want to wear the wrong mustache or forget your accent or say, "Who's Violet?" after you have told someone that Violet is your wife's name. You must know your disguise character thoroughly enough to *be* that person in a disguise situation. Don't tell detailed, complicated stories that you won't be able to remember, and keep your physical disguise simple enough that you can repeat it without worrying whether you've got it right.

LEARN TO BE QUIET

What we just said about telling stories applies here. Amateurs tend to try too hard to convince others of the reality of their disguise character. This is because they feel insecure in their ability to carry off the disguise and give their audience too much credit for sharpness. Almost apologetically, they babble on and on, giving a lot of fictitious background material to lend weight to their assumed identity. Aside from being totally unnecessary—in most situations, no one is going to assume you're any different from what you present yourself to be—such babbling is counterproductive. If you have ever involved yourself in telling long, complicated alibis, you know how difficult it is to keep from tripping yourself up under questioning or just in everyday life. It seems something you can't explain always comes along to blow your cover. This is always embarrassing and sometimes dangerous, and it has driven more than one man to telling the truth. Generally speaking, the less complicated the story, the less chance you have of messing things up. Resist the impulse to be clever; it's more likely to backfire than if you keep things simple.

As Calvin Coolidge once said, "If you don't say anything, you won't be called upon to repeat it," and, on another occasion, "I never got in trouble for anything I didn't say." Keep-

ing quiet may sound easy enough, but for many it is next to impossible. Talkativeness is a common nervous habit, like eating and smoking, and just as difficult to control for those who are habituated to it. We mentioned before that disguise amateurs tend to explain too much in order to give substance to their assumed characters. Add to this the stress of a disguise situation, and the compulsive talker will have a hard time keeping his mouth shut. Self-control is the key here. Learn to relax if this is your problem, and try to stay focused. Then, keep the focus on others rather than on yourself.

This comes under the heading of putting yourself into the enemy's position, as Musashi advised samurai to do. Realize—and remember—that most people are really much more interested in themselves than in you and would rather talk about themselves than about you. Encourage this tendency, especially when you want to get them off a particular track. This must be done with a certain amount of tact, however. A tight-lipped, steely eyed interrogator puts people up tight. Also, many people feel uncomfortable when someone listens to what they have to say but doesn't reveal anything about himself in return. This can be interpreted as a power play or as a sign that the silent person is trying to hide something. Naturally, this leads to distrust of the person who refuses to talk.

LEARN TO FLIMFLAM

So what do you do if you can't blab, and you can't keep quiet? Well, it does seem like a contradiction, but there are ways around the problem. When you are mingling socially with another person or group of people and polite conversation is called for, small talk is harmless and fairly easy. If the conversation shifts to more personal topics and you would rather not get in too deep, shyness is a good defense—if, of course, it is compatible with the personality of your

disguise character. Simple, short, polite answers are always acceptable in reply to direct questions, and most people, at least in social situations, know that insisting on more from you would be rude on their part. Besides, they are probably dying to throw in their own two cents worth, anyway. Reveal or hint at a few intimate details of your disguise personality's life or feelings and leave it at that. Once again, don't be so self-conscious that you assume that you are the main subject of interest. Unless others are paranoid or have reason to distrust you, they will be anxious to get the conversation back to themselves.

If you can learn to be a charmer or a smooth talker, and if this trait suits your disguise personality, so much the better for you. This is something that can be learned, although for some it appears to be a natural gift.

The real secret is in letting others think that you understand and appreciate them, not in proving that you're anything special in and of yourself. Don't flatter too much verbally; this embarrasses people and makes them feel you're after something, especially if they know that what you're saying isn't true. Accepting and sympathizing with their faults is far more charming, *but only if they have first confided these faults to you.* You don't want to say, for example, "I can't help but notice that you're cross-eyed and pretty uncoordinated, too, and I want you to know that I can really empathize with that."

When someone makes a confession, smile and be understanding. Try to get a feel for when they want you to contradict them, too. When a person tells you, "I guess I'm just a dumb and ugly kind of girl," she usually wants to hear you disagree with her, not say "Gee, that must be rough."

Accepting the flaws, prejudices, and confessed sins of others can be more charming than pretending that they don't exist, on occasion. I know one man who is enough of a con artist to smile knowingly at whomever he's talking to,

as if he knows everything the other guy is thinking. He is so convincing at this that people tend to believe he really does understand them and proceed to spill their guts to him about whatever they have been holding back. When questioned about this knowing look, the man says that he knows how effective it is, but that it is nothing more than a trick; he actually has no clue as to what other people are thinking and is often quite shocked to find out. In the same vein, camaraderie is more readily encouraged by professing to share the same dislikes than by sharing the same likes, and by enjoying the same guilty pleasures rather than the same innocent pastimes. People tend to open up more to those they consider partners in crime, even if the "crime" is no more serious than junk food addiction. To be on the safe side, however, it is often better to make the partnership implicit than to make definite, possibly damning, statements that could backfire later.

While knowing smiles and other facial expressions can be used to advantage in conversation, remember that too much eye contact makes most people nervous. Get a feel for this. Eye contact can be interpreted as an encroachment on personal space; it is often seen as threatening, too intimate, or as a sexual come-on.

Laughing at other people's jokes and agreeing with them about the faults of others are generally safe ways of becoming known as an intelligent person with a great sense of humor. (Just don't agree if they're complaining about their families.) Listening and asking questions to show that you are sincerely interested, without pumping for information, is another surefire way of appearing intelligent.

When you want information the most, you will have to be most careful not to push. People like a listener, but if you act too manipulative or insistent, they are apt to become distrustful and clam up. By agreeing, asking questions, and divulging a few things as if they were very important to you

(you can decide on a few basics when you are developing your disguise character), you will give a good impression without giving yourself away.

EFFECTS OF ALCOHOL AND DRUGS ON DISGUISE

When you are acting the part of a disguise character who is different from you in accent, point of view, or in other respects, you can get into trouble by drinking and taking drugs. Your defenses and inhibitions are relaxed when you drink or smoke marijuana; speedy drugs like cocaine tend to make you talk too much, and so on. If you get stoned, you will be likely to reveal more about your real identity than you want to.

Sometimes abstaining can be a problem, however. When you are with a group that indulges in mood enhancers as a matter of course, you may feel uncomfortable about refusing to partake. Drugs are a sort of badge of membership in many groups. The preferred drug may be marijuana, coke, cigarettes, martinis, or Mickey's Malt, but whatever it is, refusing it may be tantamount to refusing entry into the social circle.

This problem has several possible solutions. You can use your common sense and your knowledge of your own limits, and then indulge up to, but not over, your limit. In this case, find out what your limits really are. Drugs and alcohol have a negative effect on judgment. Extend your video self-examination to allow for this by taping yourself while you're mildly inebriated. Then play it back sober and see how you performed. You may be surprised!

If alcoholic mixed drinks are the drug of choice in your group, you might try mixing your own and leaving out the alcohol. (The Gibson martini got its start in just such a situation as this. Hugh Gibson, an American diplomat, didn't feel up to consuming the gin martinis which were *de rigeur* at the cocktail parties his office required him to attend. He made

private arrangements with the bartenders and waiters to pour him "martinis" consisting of straight water, substituting a small pickled onion for the traditional olive as a means of identification.)

Other solutions involve excuses or out-and-out lies about why you are unable to indulge. Health problems are generally accepted, and may even earn you a certain measure of sympathy. Take the trouble to learn the facts about the effects specific drugs have on specific health conditions so as not to leave yourself open to argument. Alcohol tends to raise blood pressure and aggravates blood sugar abnormalities (diabetes and hypoglycemia). Marijuana, on the other hand, is said to lower blood pressure and decrease levels of blood sugar—hence the notorious aftereffect known as the munchies, the body's attempt to stabilize its sugar level.

Psychological health problems with drugs, learned the hard way, are also generally well received. Alcoholism, both a physical and psychological illness, is an acceptable excuse for not drinking, and one a hard-drinking crowd will be able to relate to. For those who want to avoid marijuana or speedy drugs, pleading induced paranoia may be the key. Some people who have overindulged in psychedelics or animal tranquilizers (angel dust) over the years develop psychotic (crazy) reactions to the drugs, and some problem drinkers have the same reaction to alcohol. Downers (narcotics, barbiturates, and tranquilizers, including Quaaludes and Valium) cause depression in many users. Pleading such problems will not alienate you from the group because it will show that you have, in effect, already earned your membership and have the scars to prove it.

A final warning: If you do resort to health problem excuses, remember what you have said! A self-proclaimed diabetic who refuses a beer and then gobbles candy bars exposes himself to doubt and suspicion.

PERMANENT DISGUISES

For various reasons, certain people choose to go underground, changing their identity for good. This subject is too complicated to cover here in detail, but the main points can be outlined.

Identification papers can be obtained to prove that you are a new person. Forgery and retouching are not recommended, however; you will do better to get the real thing if you can. To start out, a valid birth certificate is imperative, as this document is required for a driver's license, passport, and other kinds of I.D. The "classic" means of obtaining a new birth certificate is to send or ask for the certificate of another person of the same age and sex whom you know to have died in childhood. If you do not know personally of any such person, consulting obituary columns of old newspapers (these are available at most public libraries on microfilm) or visiting graveyards to check out the tombstones may turn up some possibilities. You may also simply look through the death certificates on file in many countries; in some areas, however, this is either forbidden to the public or will arouse suspicion.

Find out what information is required to get a copy of the birth certificate in the county in which your subject was born. In some counties this is difficult to do, while in others it is very easy. Date and place of birth and complete names of both parents are generally required. Ask the clerk in person or write requesting a form to fill out. Often there is a fee, usually under $5, for the service. One woman I know wrote and asked for her husband's birth certificate, saying he had lost it, which was true. The county clerk's office promptly sent her a copy, no questions asked.

In some cities, especially in California, birth and death certificates are interfiled, but this is rarely the case. If you want to be sure, stick to rural areas where the files are hardly

ever cross-referenced. However, stay away from the one-horse town where everybody knows everybody's cousin—or where everybody *is* everybody's cousin. Such towns are becoming rare these days, but they do exist. The county clerk will know that you are up to no good in requesting the birth certificate of someone everybody knows died years ago unless you can come up with a very good story.

After you have a birth certificate, other papers can be obtained under that identity. For a good book on this subject, see *Paper Trip II,* by Paladin Press. It gives all the information you are likely to need on getting a new I.D.

Getting your papers in order may be the easiest part of creating a new identity. Depending on who is looking for you and how hard they are willing to look, other changes may be necessary as well.

The first step in establishing a new identity is to leave town. As mentioned earlier, trying to change when you are keeping company with family, friends, and acquaintances is all but impossible. Not only will your secret be compromised by staying in the same place, but old patterns of behavior will be apt to trip you up. To be safe you will have to move someplace where nobody knows you from Adam.

If you anticipate that you will be looked for by the feds or by private investigators, you may also have to make changes in your lifestyle and personal appearance. New sports, political, and hobby interests as well as a new line of work will throw them off the track and will eventually make real changes in your lifestyle and outlook. If you can hold out long enough, the passage of years will alter your appearance and personal style enough that you will be difficult to identify.

In extreme cases, some people have resorted to plastic surgery in order to throw their pursuers off the scent. Abbie Hoffman is one example of a man who took drastic measures to change his appearance by having facial plastic sur-

gery. The combination of a "new" nose and the natural effects of the aging process make the Abbie Hoffman who has recently come out of hiding difficult to correlate with the young Yippie Abbie Hoffman of the sixties. Hoffman also changed his lifestyle, while not entirely giving up his aim to revolutionize certain aspects of American life and philosophy. When he went underground, he worked within the system on such projects as cleaning up U.S. waterways. For some, going underground can actually provide an otherwise unattainable opportunity to follow new interests or to implement old interests in new ways.

Obviously, for permanent disguise purposes, false beards, makeup, and putty noses are not the answer. For many, however, plastic surgery is too extreme, too expensive, or not medically sanctioned, and hence impossible. Some effective long-term disguises can be achieved by substantial weight loss or gain; rigorous physical exercise, especially body building, for those who have not previously made a practice of working out; and alterations in dress, hairstyle, speech patterns, and mannerisms to constitute an entirely different stereotype.

Baldness is a noticeable, hard-to-disguise condition, at least on a permanent basis; once the word is out you wear a toupee, it spreads like wildfire. The first real cure for baldness may be on the market soon, if it meets FDA approval. Users of a certain prescription drug noticed that it had the undesirable side effect of producing body hair. Researchers have been experimenting with topical use of the drug on the scalps of bald volunteers and have discovered that 20 percent of those participating as guinea pigs have grown a good quantity of head hair as a result. If all goes well, the drug could eradicate baldness among at least a portion of the hairless populace in the coming years.

Permanent disguise is a desperate measure for a desperate situation. It is up to the individual to decide whether a com-

plete identity change would be worth the risks alienation and living on the run would entail.

5. PHYSICAL DISGUISE TECHNIQUES

The use of makeup, clothing, and accessories for disguise purposes is not new. People have been disguising themselves for centuries. Ulysses fooled the cyclops into believing that he was someone else, then blinded the poor monster's one eye. And remember how Robin Hood disguised himself in order to enter an archery competition unobserved? Anyone would think that by this time people would have got the hang of it, but confusion still abounds.

Cosmetics of different kinds are used for theatrical, beautification, and disguise purposes. Sometimes these three areas overlap, and perhaps this explains to some extent why so many would-be disguise artists get them mixed up. Theatrical makeup is designed for the stage and for film. Stage makeup must be overstated in order to get the point across; cosmetic techniques that work for the stage and photography do not necessarily work in everyday situations. Watching a movie or play or looking at a photograph, we are willing to allow for effects that we would not accept if we were to see the actor standing in the checkout line at the 7-Eleven. A good street disguise must give the wearer the illusion of being someone or something other than who he is, and it must do so in a believable way.

Beautification, the most common use of cosmetics, is not the main point of disguise, although a disguise may sometimes involve beauty techniques. Women tend to use cos-

metics to glamorize, while men tend to go for stage makeup in order to disguise themselves. It seems difficult for women to let go of the "makeup trick" mentality and make themselves appear masculine, older, unattractive, or commonplace. Men, accustomed to thinking of cosmetics as feminine, may feel safer in using makeup designed for stage use because it has a tradition of respectability for men as well as women. (Men, in fact, wore stage makeup first; in classical Greek and even Shakespearian drama, male actors played all the roles.)

Because of their greater skill and ease with cosmetics, women have an advantage over men in disguise makeup, and they also can get away with less subtle use of cosmetics, since any detectable trace of the stuff on a man's face calls attention to him immediately. The products made for street use, however, are designed to be undetectable when used with discretion, in any light and from any distance. For this reason, they are more suitable for most disguise purposes than stage makeup. Street cosmetics come in every skin tone and shade and are available in liquid, cream, and powder form. Some are waterproof and, while none last forever without retouching, some are remarkably long lasting. Sprays are available which set the makeup after application. Furthermore, there is a wide array of excellent products available in almost every pharmacy and department store in the country. Unfortunately, it is difficult for a man to select the cosmetics he requires without calling attention to himself!

One of my favorite disguise stories was told to me by an American friend of Irish descent named Patrick McGowan. As a young man, he became involved in IRA activity in Ireland and was allowed to return to the United States under the condition that he not enter Ireland again. As luck would have it, however, some urgent business came up in Dublin, and he felt that he had to participate. Patrick was not wanting in pluck; some people, in fact, accused him of foolhardiness in his exploits. He had smuggled various wares across

international borders, disguised himself so that his own mother wouldn't recognize him, and forged himself several sets of passable identification, all by the age of twenty. In this case, though, he was at a loss. He was unable to come up with a usable passport at such short notice; the only one he could get his hands on was his sister Sheila's. When she presented it to him, even the resourceful Patrick couldn't see what good it was.

"What's wrong with it?" his sister asked. "It's a valid passport, and everybody always says we look alike."

"But you're a girl!" Patrick told her, as if she were crazy.

Sheila marched him off to the bathroom. In a little less than an hour, he was staring at himself in the mirror, flabbergasted. Shaved, made up, decked out in his sister's clothes, and his collar-length hair restyled, he didn't look exactly like Sheila, but he did look like a young woman. And, as his sister said, there was enough family resemblance between them that he looked like her passport picture. He could wear Sheila's skirts, but his shoulders were too wide for her blouses, and his feet were way too big for her shoes. At first, he flatly refused to go shopping with her, but she convinced him that, if he was really serious about disguising himself, he might as well practice in a department store where the worst that could happen would be running into a friend or getting a few funny looks. Finally he agreed and went off with Sheila wearing a unisex outfit of jeans, sweatshirt, and shower thongs.

"I was never so self-conscious about my feet in my life," he told me. "The shoe salesman didn't seem to mind, though. He kept trying to flirt with me while he was putting those little footy stockings on and pushing my feet into shoes with bows. I wanted to deck him."

After several days of coaching from his sister, carried out under the utmost secrecy, Patrick was ready for the transatlantic flight.

"Fortunately," he said, "everything went fine. I was nervous, though—kept running into the john to check my four o'clock shadow and makeup. I don't have a heavy beard, and at that age I was skinny and babyfaced anyway. I thought sure they'd say something when I got my passport stamped, but the guy just smiled and told me to watch out for leprechauns. I couldn't get my Irish friend to recognize me when he came to pick me up at the airport. Then when he finally realized who I was he was laughing so hard he could hardly drive me to his house. I went to some meetings—appropriately dressed as myself, of course—and when it was time to go home I had to go through the whole rigamarole over again. Luckily, my friend's wife seemed delighted to help me out with the details. I passed through customs without a hitch, trying just to smile and nod when I could, since I wasn't too sure of my voice. It wasn't till I got home again that it occurred to me they could have done a strip search, and I started shaking. I don't know why I'd never thought of that before, with all the experience I'd had, but I didn't. I guess I was just damn lucky."

To look at Patrick today, it is difficult to imagine that he could ever have passed as a girl. He is stocky, mustached, and not effeminate in the least; but I take his word for it, especially as he still can't tell the story, even after eight years, without obvious embarrassment.

One solution to the problem of makeup is to order cosmetics through the mail. If you choose this route, order good name brands to make sure you get good quality. While some people claim that all cosmetic products are essentially the same whatever the price, I have not found this to be true. High prices, however, are no guarantee of quality. Department store fliers advertising mail-order cosmetics like Charles of the Ritz are a good bet. In general, the glossier and higher class the ad, the better the product. There is usually a form to fill out specifying what com-

plexion and skin tone type you are, and I advise you to fill this out according to your disguise needs. Send for a kit that includes a variety of colors and kinds of makeup to make sure that you get what you require. You can experiment with them in the privacy of your own home.

EQUIPMENT

If you visit the store yourself, perhaps with a woman friend as cover, you can choose with more reliability. Once again, good name brands, like Revlon, Max Factor, and Elizabeth Arden, are best. Most top-of-the-line cosmetics displays have testers which you can use to determine which products are best for your needs. (By the way, for those unfamiliar with makeup etiquette, the proper way to sample a cosmetic is to dab a small quantity on the inside of your wrist—the skin area most like your face—and then smear or rub it slightly.) The makeup basics are outlined below.

Foundation: A skin-colored makeup base. It may be a thick liquid or in pancake form. The former is dabbed onto cheeks, nose, chin, and forehead very sparingly, then lightly blended over the entire face with the fingertips. Pancake makeup must be spread over the face with a damp sponge. It is more long lasting than liquid but tends to give a more opaque, hence less realistic, cover.

Blemish cover: May be in stick, liquid, or cream form. Used under foundation to cover blemishes and shadows. White cover, or highlighter, is used under foundation to lighten an area, thus making it appear slightly raised. Can be used to downplay beard shadow after shaving.

Blush: Formerly called rouge and restricted to red and pink shades, blush now ranges from pale pink to maroon and brown and is excellent for both shading and coloring. It comes in cream, stick, gloss, and powder form.

Eye shadow: This comes in cream, powder, liquid, and pencil form in every color imaginable. For disguise pur-

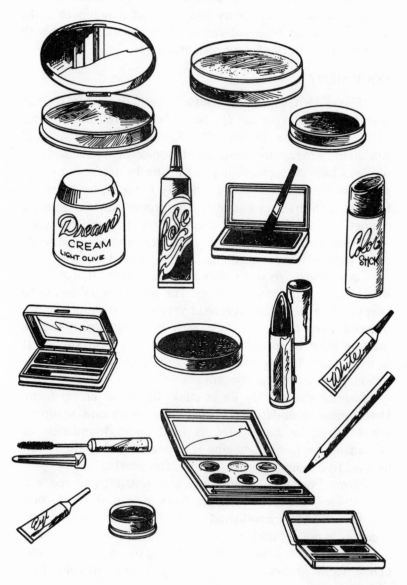

Various cosmetic aids you can use in creating your disguise appear above.

Brushes

poses, eye shadow lends itself well to shading (making the eyes or cheeks appear sunken, and so on) and is also useful for faking bruises.

Mascara: This eyelash darkener comes in wand form or in a cake. The wand is more common and is easier to use, but tends to stick the lashes together in clumps. It does work well on mustaches, but must be combed through afterward with a mustache comb. Cake mascara comes with a small, stiff brush which must be moistened and rubbed over the cake; the color is then applied to the lashes. It is not waterproof—wand mascara usually is—and takes more skill to apply. Its advantage is that it colors the lashes, brows, and mustache in a natural looking way without an obvious mascara appearance. Cake mascara is old-fashioned, and thus sometimes hard to find. Maybelline's is fine, and quite inexpensive.

Eyebrow pencil: I have found this hard to use without being obvious, but it can be done. Practice just darkening the brow hairs, without drawing on the skin beneath.

With practice—and I mean a lot of practice—cosmetics can be successfully used to create illusions with an entirely natural look. Because making up the face is essentially a kind of painting, hand-eye coordination and artistic ability help but are not absolutely necessary. A good eye, however, is necessary in order to arrive at the desired result. Experimentation will pay off. If you are not already adept at cosmetic use, take heed of the following points.

- Use only a small amount of any cosmetic. Be careful to avoid globs, and blend into surrounding area. If you need more, add it gradually until you have the amount you need to do the job.
- If you use shadow and blush for shading and color, use foundation sparingly underneath. This will help you blend the colors in more smoothly and avoid unrealistic blotches of color.

- Blend foundation into the underjaw area and neck so as not to create a mask effect.
- Check eyebrows, hair around the face, and facial hair for telltale flecks of makeup.
- After makeup is complete, blot face with a barely damp washcloth to remove any excess.

ILLUSIONS

Various special illusions are possible through the use of cosmetics. Try the ones described below and experiment with your own.

Various products are available for giving the skin a tanned appearance. I have found the most effective of these to be the tanning gel which comes in a plastic tube. Bonne Bell makes a good one. Used sparingly, it is realistic looking; it comes in several shades and washes off with soap and water. It also tends to streak with water, unfortunately, so try not to cry or go out in the rain when you've got it on.

While we're on the subject of suntanning: It will be useful for the disguise artist to avoid getting an obvious sunburn, which could lead to identification. Presun preparations containing PABA help to prevent burning. To disguise a burn, try a pale green foundation (large department stores carry this) beneath your regular foundation. It won't entirely eradicate the redness, but it helps. When faking a burn on the face, apply pink blush mainly on the nose and directly over the eyes. Raised areas get most of the burn. For serious, long-term skin darkening, some doctors can be prevailed upon to prescribe medication that increases the natural melanin count in the skin. The author of the famous book *Black Like Me* made use of this method. Doctors will usually not prescribe such treatment, however, unless the patient is very pale and in danger of burning when exposed to normal sunlight.

For quick-change purposes you may prefer to wear sun-

screen when out in the sun, then add color with cosmetics when you need it. A construction worker, a farmer, a skier, and a beach bum all have tans, but their tan lines are different. You can fake any or all of these tans in turn and then appear pale and untouched by the light of day when you want to impersonate a library researcher.

If you have grown a natural beard for disguise purposes, remember that the unbearded portion of your face will be noticeably darker than the bewhiskered part when you shave. Anyone who makes it his business to pay attention to such things will know by looking at you that you have shaved recently.

Age can be faked to a certain extent by the use of shading. Exaggerate the natural lines that form in your face when you grin (don't draw a grin on your face, though; just use exaggerated facial expression to show where the lines will appear in ten or twenty years). Use soft eye shadow pencil in a brown, maroon, or gray shade, depending on your skin color. This must be done with a light hand, carefully blending in the color afterward so that only the merest indication remains. Blue-gray eye shadow may also be subtly shaded into the under-eye area, and a blush darker than your normal color can be used to create the illusion of sunken cheeks and temples.

To create a sickly appearance, use a light-colored foundation and blue-gray or purplish shading under the eyes.

TECHNIQUES

Changing your facial shape may be handy in order to avoid identification. Police artists use illustration books with overlays when getting descriptions from witnesses. They can widen, lengthen, and slim the facial shape in the book by flipping the overlays until the witness is satisfied that, yes, that's what the person looked like. Even if you don't plan to

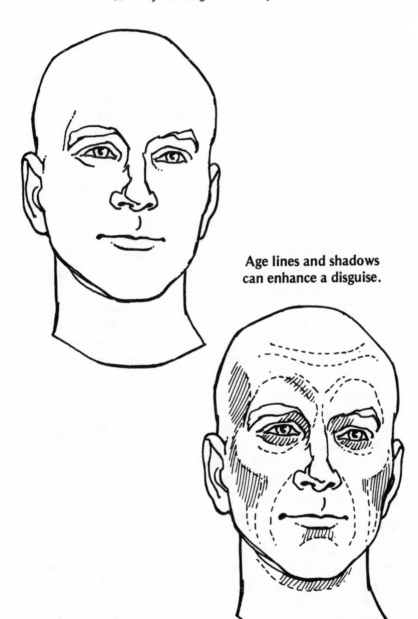

Age lines and shadows
can enhance a disguise.

become a police artist, of course, you may want to make use of this aspect of disguise.

Round face: For a thinning effect, counteract horizontal lines by applying blush vertically, not across the cheekbones, but up and down. Start at the outside corner of the eye and extend color down past the mouth. Shade the jaw area with slightly dark color. (Blush often comes in a compact with two shades of the same basic color; the lighter shade is for shadowing areas to make them appear to recede, and the lighter shade is for highlighting.) When shading the jaw area, imagine that an oval has been placed over the face and shade all around it in a subtle manner. "Sinking" the cheeks by shading the area beneath the cheekbone helps, too.

Square face: Basically the same techniques work here as for the round face, but shade the jaw to give a rounder or more oval appearance.

Triangular face: Vertical lines, like those used to lengthen and slim the round face, work to narrow the triangular face across the cheekbones. Some height in the hair on the crown of the head helps, too, and hair or whiskers can be used to cover some of the cheek area.

Long, thin face: The opposite techniques work here. You will want to counteract vertical lines rather than create them. Apply blush horizontally, brush brows to straighten them (an arched brow lengthens), and use lighter, rather than darker, makeup around the jawline to give the face a fuller appearance. For people with lean, bony faces, this last trick gives an illusion of youthfulness.

WIGS

Wigs can be purchased at beauty parlors and stores that specialize in them or can be ordered through the mail. If you are ordering your wig through the mail, be sure to enclose your head measurements (see illustration) and a piece of your hair for matching purposes. It is usually better to get

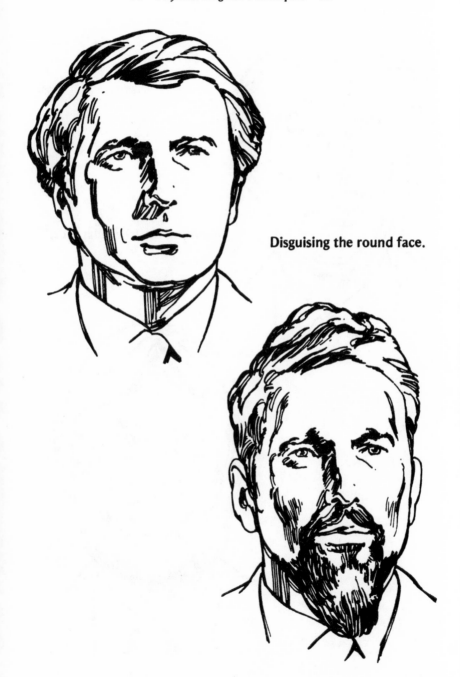

Disguising the round face.

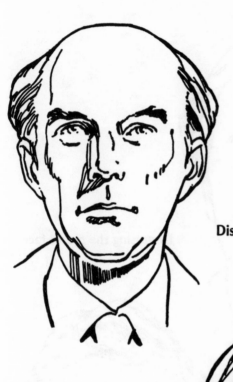

Disguising the triangular face.

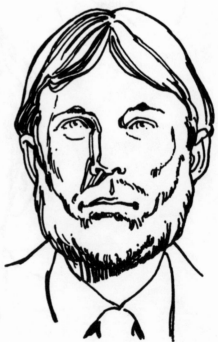

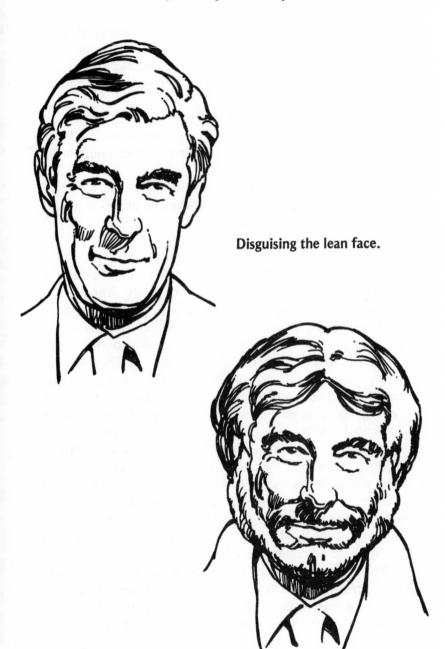

Disguising the lean face.

yourself fitted in person, however, and to discuss everything firsthand with an expert. Human hair is most expensive but also most realistic. Some synthetic wigs look real enough for many purposes. The Bob Ellis Co. makes wigs of half human hair and half synthetic materials.

If you have long hair, wrap it on top of your head and hold it there with a band made from a nylon stocking. Make sure all the strands are safely tucked in before you put on the wig.

There are, of course, disguise occasions when you won't need to look natural. Some of these are impersonating a clown, Santa, or other costume character.

HAIR

There are many different products on the market for altering hair color temporarily or permanently. When selecting any of these products, it is best to stick to well-known, reputable brands. Clairol and L'Oreal are both good bets.

Temporary color: These are rinses or shampoo-in colors that can be removed in five or six washings. They are not usually intended to alter the natural color of the hair too much but are designed to cover gray, add shine, and so on. A rinse lighter than your present hair color will not make an appreciable change in your appearance. It is unlikely that anyone will notice even if you go several shades darker. Choosing a rinse that is much darker than your usual hair color will afford a usable disguise, however. Often the red and auburn shades and the straight black coloring are unrealistic looking; for some disguises this may be exactly what you want. A vain or flashy personality type may be best personified by an obvious dye job.

To add gray or white streaks, you can experiment with Nestle spray-on temporary color, available at many drug stores or by mail from Jack Stein Make-Up Center in Boston. This is not always believable enough for your requirements. Some

Temple to Temple

Hairline to Nape

Ear to Ear

Across the Nape

Around the Head

Ways to measure a head for a wig are shown here.

times white liquid shoe or boot polish can be applied to small strands and combed through to good effect. Try out these things before your actual "disguise performance" takes place.

Permanent color: Permanent hair-color solutions are called dyes. Kits for do-it-yourself hair dyeing are available in pharmacies and department stores and in outlet stores for products used in beauty parlors. Because dyes are permanent, it is especially important to use a good product. Once again, I would recommend Clairol or L'Oreal. The kit will contain "developer," which is actually peroxide; the color itself, which is massaged into the hair after the developer; and conditioner.

Changing hair color by one or two shades will not effect a disguise; in fact, the people who know you best would probably not even notice. To create a different image you must make a more drastic change, going from black to red, blonde to brunette, mousy to platinum. Make sure, though, that your skin tone and hair color are not at variance to an obvious extent. A pale redhead, for example, will have a hard time carrying off raven black hair without make-up, subtly and skillfully used.

Artificial facial hair: False beards, mustaches, and side-burns can be made to suit the individual occasion using human or yak hair or crepe wool. Human and yak hair are expensive and time consuming to work with, however, and crepe wool facial hair is best seen from a distance; up close it looks fake. For those interested in making their own false beards and mustaches, I recommend *Film and Television Makeup* by Herman Buchman, published by Watson-Guptill Publications. In general, lace-backed, human hair pieces are most convenient. With care they will last for a long time, although they are easily spoiled by rough handling. They are handmade of human hair knotted onto a lace net backing, and therefore are more fragile than the five-and-ten-cent store Halloween variety.

Facial hair need not be an exact match with head or body hair. Many people have mismatched hair and beards. Just make sure that the discrepancy is not too great.

To apply the facial hairpiece, hold it against your face as you want it to fit. Extra hair and lace backing may be cut off. When you know the way you will be placing the beard, apply spirit gum adhesive to the lace side and, positioning it carefully, fit it to your face, using a cloth to press the hairpiece firmly against the skin.

A cloth moistened with acetone, or spirit gum remover, is pressed against the facial hairpiece for removal. Be careful not to inhale the fumes. When cleaning the piece, lay it lace side up and apply acetone with a brush, being careful not to allow acetone to touch enamel, varnished, or laquered surfaces, as it will destroy the finish.

REMOVING UNWANTED HAIR

If you are a man who wants to disguise himself convincingly as a woman, there are some aspects of hair removal you may not know about.

Facial hair: As you know, even a close shave does not last long and leaves a bluish or gray shadow over the whiskery part of your face even when you are impeccably clean-shaven. You may not notice this shadow on a man's face, but if a woman had such a shadow it would look peculiar. This must be corrected either by using a light or white cover under cosmetic foundation or by selecting another means of hair removal.

Electrolysis: This works but requires a great deal of time and expense for a man with normal facial hair growth. Besides, it's permanent, so you would have to be awfully serious about your disguise to find electrolysis necessary.

Waxing: A temporary method that removes the entire hair, thus eliminating the shadow, is waxing, which is in essence a kind of plucking. Wax may be bought for this pur-

pose in a pharmacy, heated according to the enclosed instructions—a saucepan on the stove will do—and applied with a small wooden or plastic spatula, which comes with the wax. After the wax dries you strip it off, and the hairs or whiskers come too, roots and all. Ouch! If your beard is very tough, waxing may not work, but it's worth a try. Also, some people are sensitive to the process or the product, so be sure to do a spot test if you don't want to replace your four o'clock shadow with a rash.

Body hair: This is considered unsightly on women in most circles, and masculine body hair, especially of the more hirsute types, would be viewed with alarm. Some men even have hair on their backs and shoulders . . . hardly the thing if you're trying to pass yourself off as a woman.

Shaving, the most obvious choice, is fine for temporary hair removal, and a very smooth, soft finish can be achieved quickly by this method if hand lotion or body cream is applied after shaving. If you have sensitive skin, use refined, odorless olive oil (called sweet oil, available in pharmacies on request) or some other unperfumed, hypoallergenic product. Hair on the body does not usually grow back as fast as facial hair, although a day or so after shaving your skin may be getting prickly again.

Of course, other choices are waxing, electric razors, and depilatories. Waxing is effective, but it's hard to get all those little hairs if you do it yourself. Bigger cities have waxing establishments and beauty parlors where the job is done professionally. If it's a *big enough* city, you can get waxed without raising any eyebrows, whether you're a man or a woman. In a smaller burg, watch out. If you wax yourself, you can always use shaving as a backup. Depilatories are messy and ineffective, in my opinion, but many people swear by them. They chemically remove body hair, but a lot of people are allergic or sensitive to the product or the process. Electric

razors are perhaps the least likely to irritate tender skin, but also tend to give the worst shave. The choice is yours.

IDENTIFYING MARKS

Scars, moles, tattoos, and other permanent marks are often used as a means of remembering and identifying people. When artificial identifying marks are convincingly made, people will remember and describe you falsely.

Scars: Buy false-eyelash adhesive, surgical adhesive, or liquid latex (the three are pretty much synonomous), and build it up in layers on your skin until you have the type of scar you want. It may be molded and scored to some extent; you may want to color it as well, but don't go overboard. Real scars are often uneven; a V shape is common for wounds that have been stitched.

Bruises: While these marks are not permanent, they take some time to disappear. To fake a bruise, use violet-blue or lavender eye shadow. I think the powder form is best for this. Mottle it onto the skin, and then add a deeper or darker color at the center. Blend and mix the colors to resemble a real bruise; your eye will tell you when you have achieved a realistic result. This can be done extremely convincingly.

Tattoos: Have a rubber stamp made up with the slogan or picture you want to use for your tattoo. Using a regular red or blue stamp pad—these are the colors most frequently seen in tattoos—simply stamp yourself with the image. You may want to go over the outline or fill in with an appropriately colored felt-tip pen.

Needle tracks: One or more drug mainliner's tracks may be faked—should the need ever arise—by spreading a thin layer of Elmer's Glue-All or surgical adhesive in a line a half inch to an inch long following the line of a vein. The glue will cause the skin to wrinkle slightly. When it is dry, blue-gray, brown, and maroon shades of cosmetic pencil or eye

makeup can be brushed on. Keep the coloring irregular and shade it into surrounding skin to achieve the effect of a deep scar. A thin coat of transparent nail polish will seal the track, making it more long lasting. Blend the edges of the polish into the surrounding skin for added realism.

6. CONCLUSION

If you have mastered the basic techniques of disguise, learned to recognize the image you present to the world as well as how to alter it at will to suit your own purposes, and if you have developed the ability to see others accurately, then you are ready to test your skills on an unwitting audience.

Start small; for your first disguise attempts, an ordinary, nonthreatening persona is best. You will find that in the early stages brief excursions into a different identity will be enough to get your adrenaline flowing. Practicing in the privacy of your room is one thing, taking your new self into the street quite another. Don't worry if you feel foolish or shy in the beginning, and don't be hard on yourself if you stammer or find yourself seized with uncontrollable laughter. Other people won't think too much about it; they are more concerned about themselves than they are about you. Unless someone has just seen you rob a bank or hijack a plane, he won't be inclined to study your appearance.

After you have paid the utmost attention to every detail of your disguise, you will probably be amazed, possibly even disappointed, at how unobservant the average person is. The new you will be accepted at face value; people will tend to see you just as you present yourself, and act accordingly. Let's say, for example, that you generally dress and act like a respectable member of the community, then you disguise

yourself as a bum. You will feel strange as pedestrians look the other way and make plenty of room for you on the sidewalk, as if your penniless condition were contagious. "Wait a minute!" you may think. "Can't you tell this is *me?*"

The answer is no. Of course they can't. You are used to having people react to you as a respectable sort. That is how you have presented yourself, albeit unconsciously, by your choice of clothing, manner, and speech. When you present yourself as a derelict, why shouldn't people react to you as a derelict just as naturally?

Experience will increase your self-confidence. Just like the new kid in school, your disguise personality will slowly open up and find his own footing, gradually feeling more comfortable in his new world. Your experiences will bring you many surprising revelations, not only about the art of disguise as such, but also about the way others think, feel, and act, about how society operates, and about yourself and who you are. Putting yourself in the shoes of a different kind of person will teach you a great deal about what it is like to actually *be* that person, and this knowledge will help you to further develop your skills.

Ironically, as you become unrecognizable to others, you will come to know yourself. Through diligent practice of the art of disguise, you will embark on a voyage of self-discovery that will continue throughout your life. Even after you have become a master, there will always be more to learn. So have a good trip—and good luck!